Adult Coloring Book
50 Mandalas
For Relax and Anti-Stress

THIS BOOK
Belongs to:

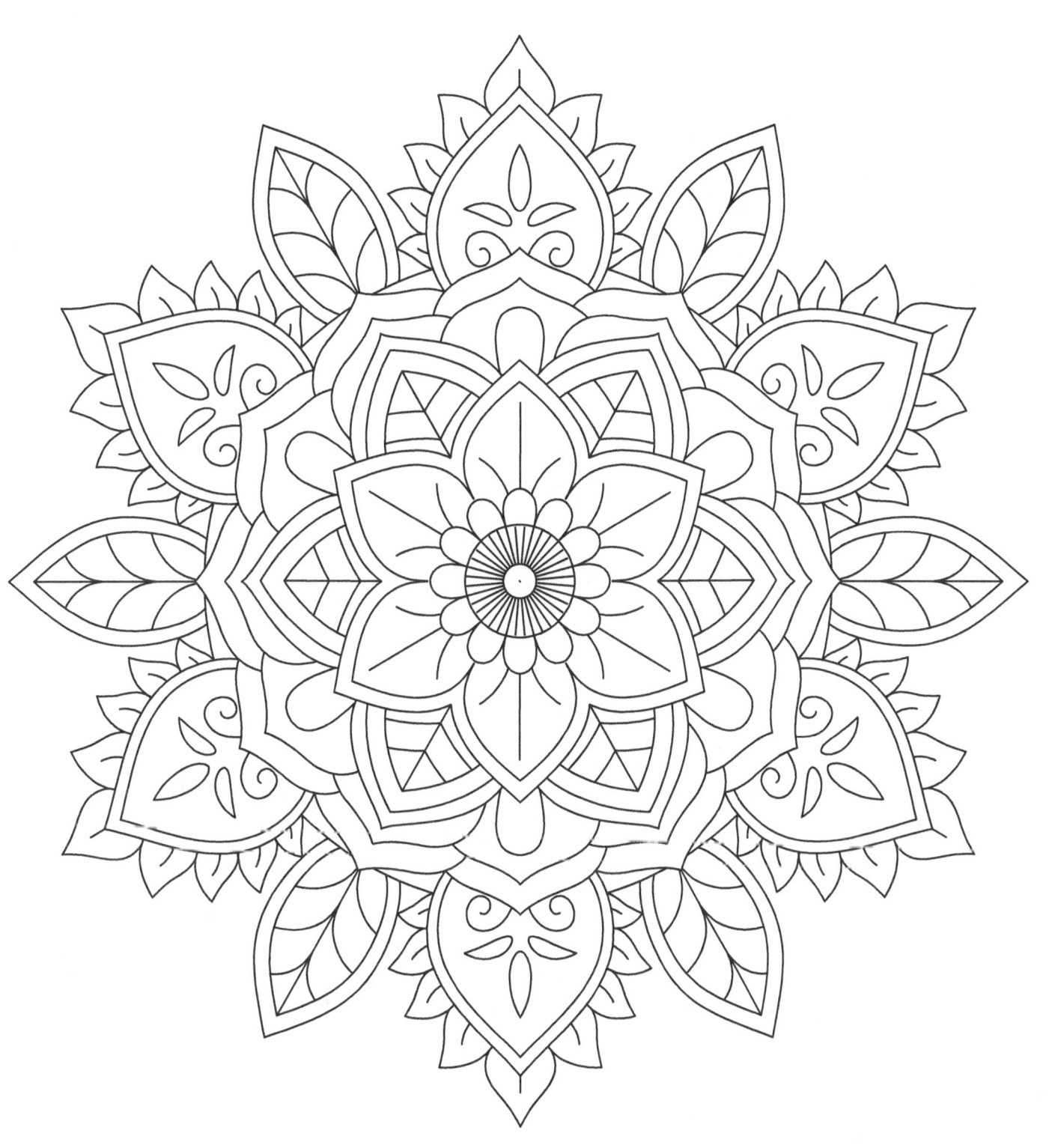

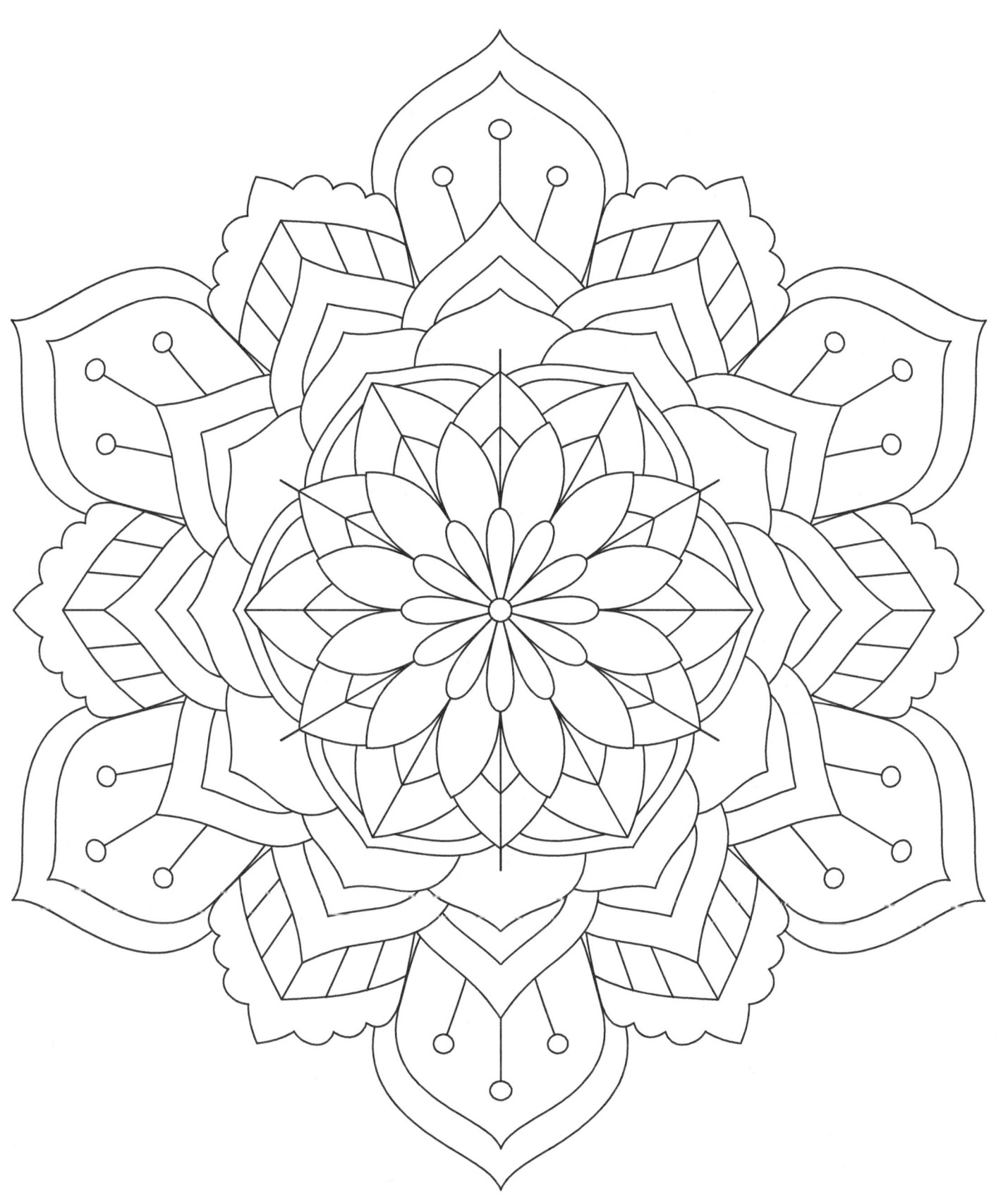

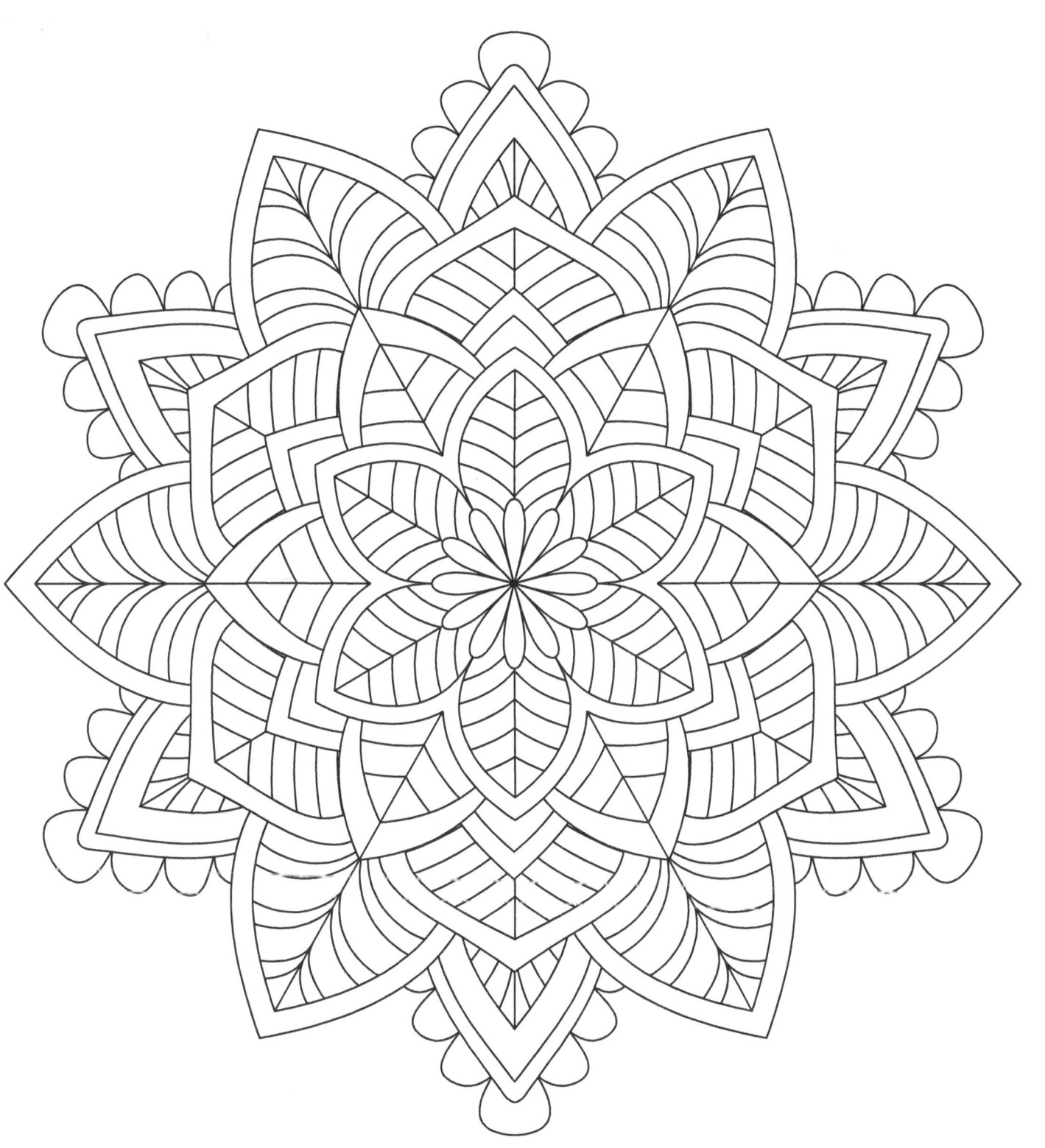

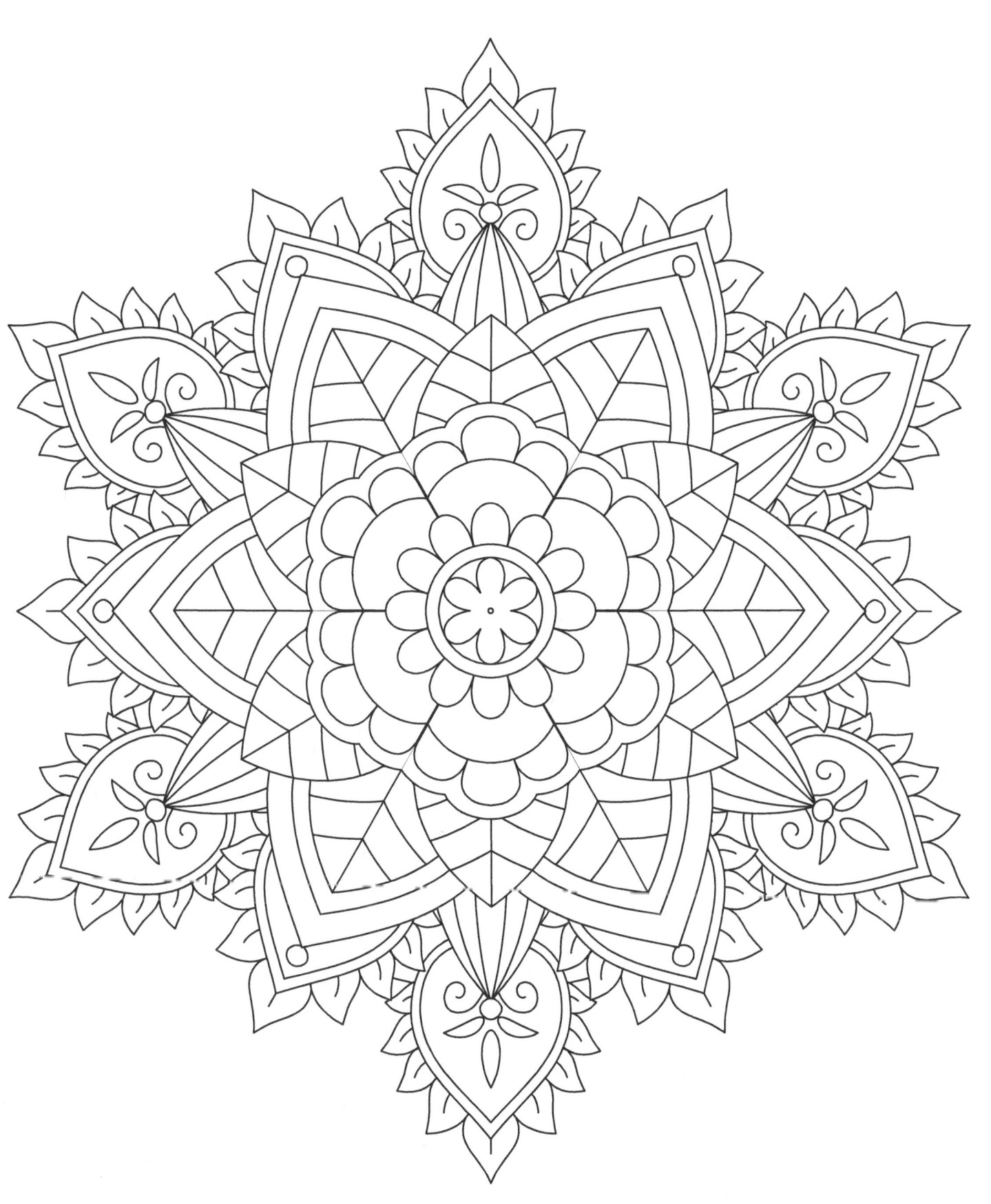

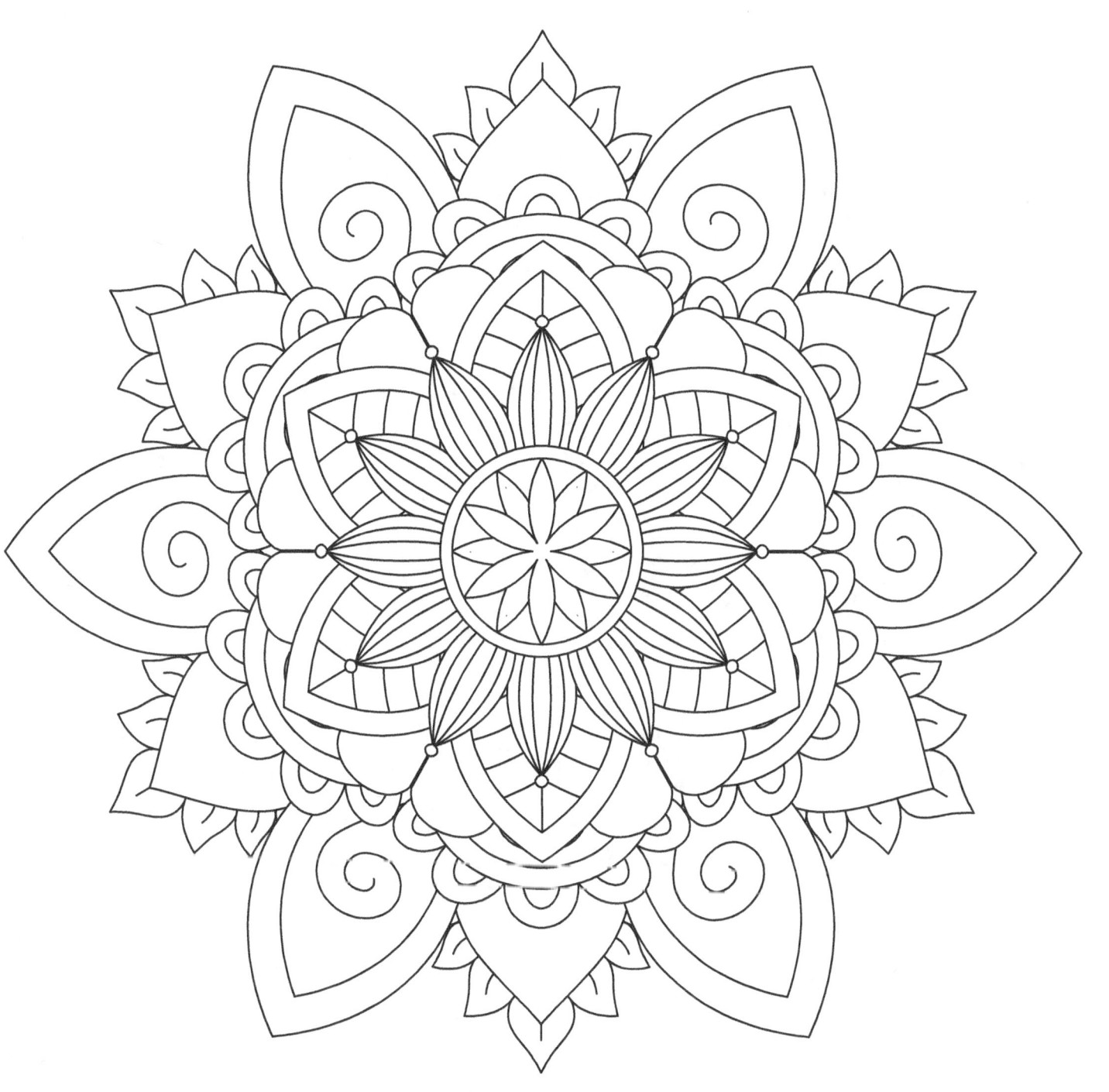

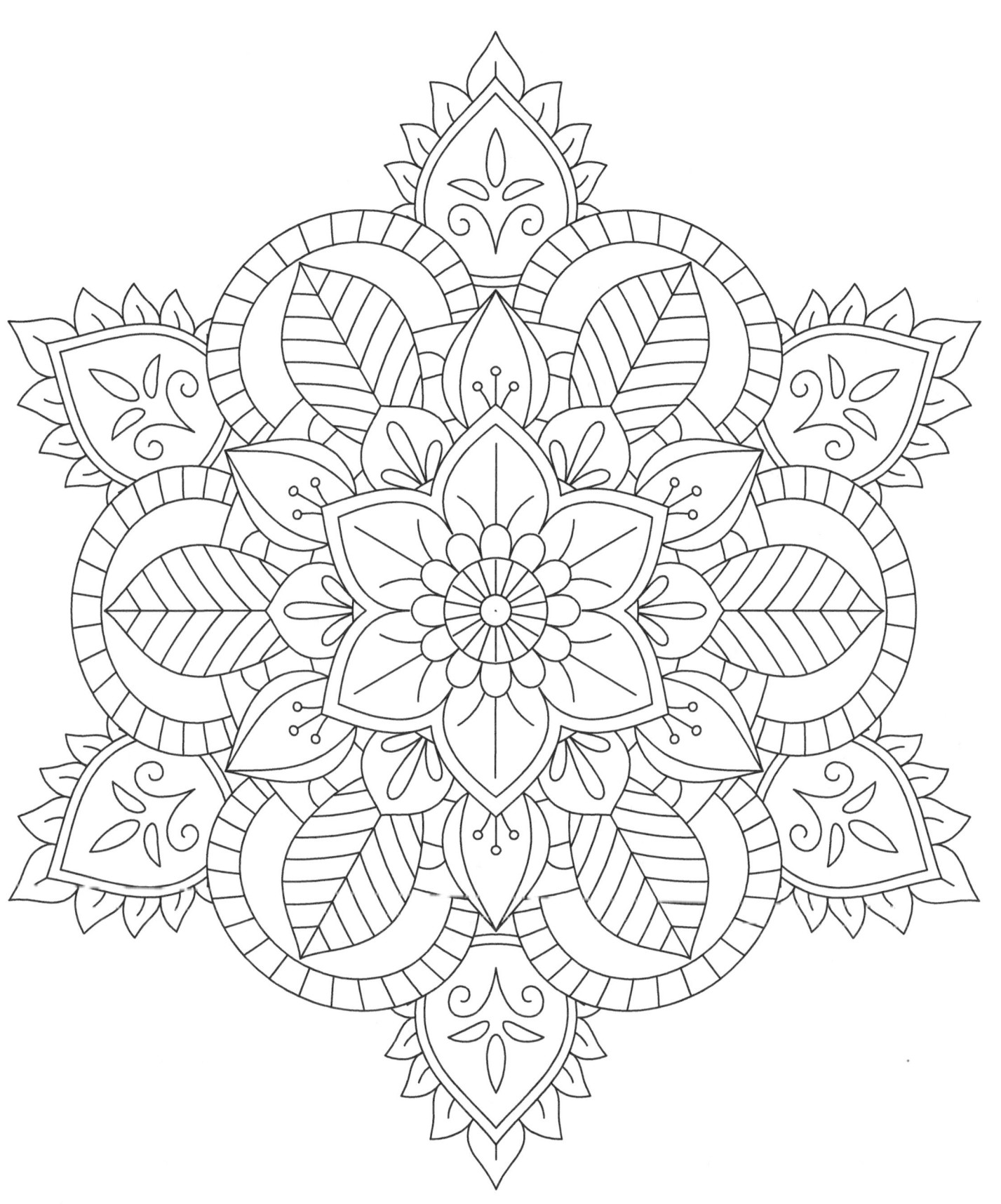

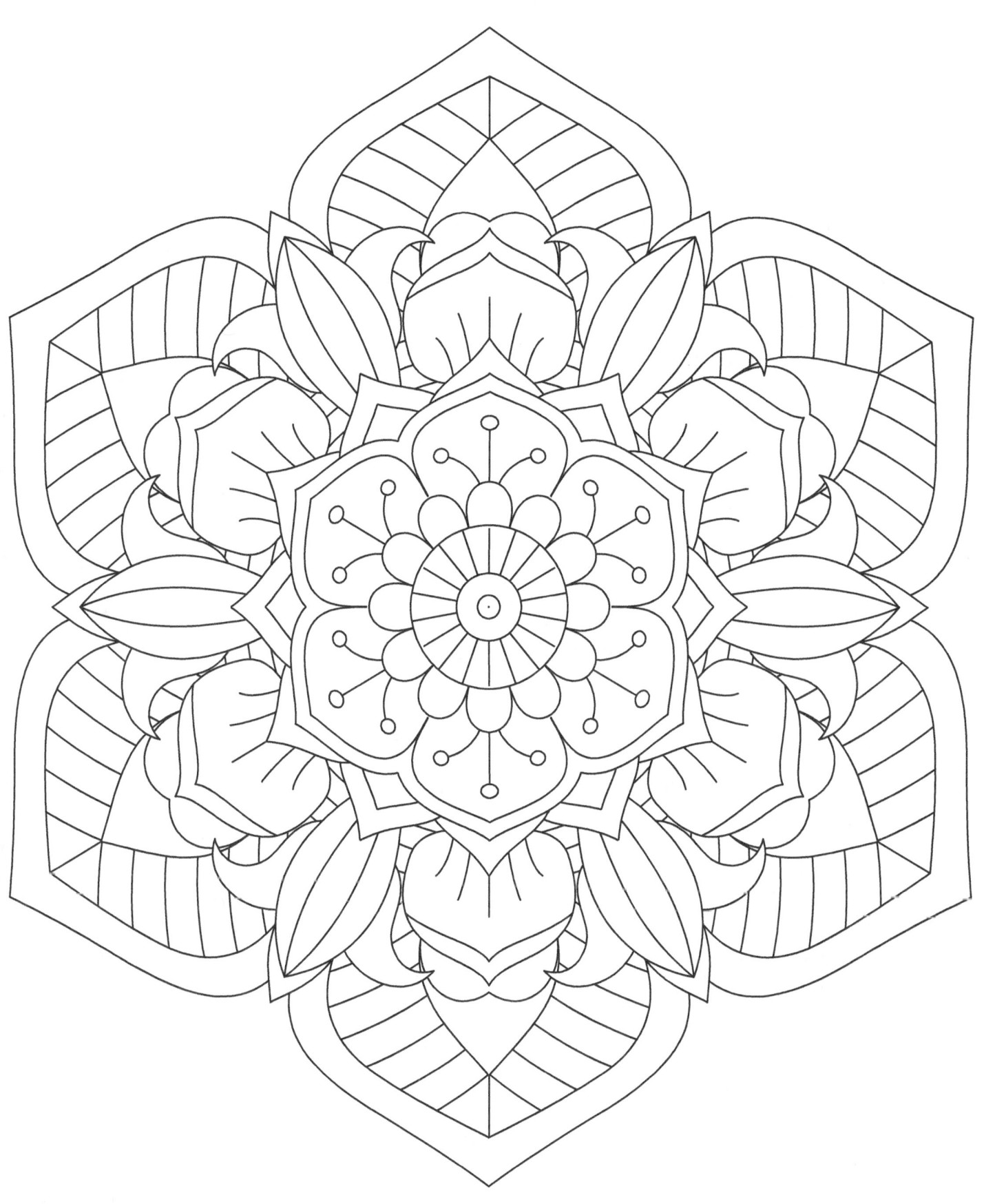

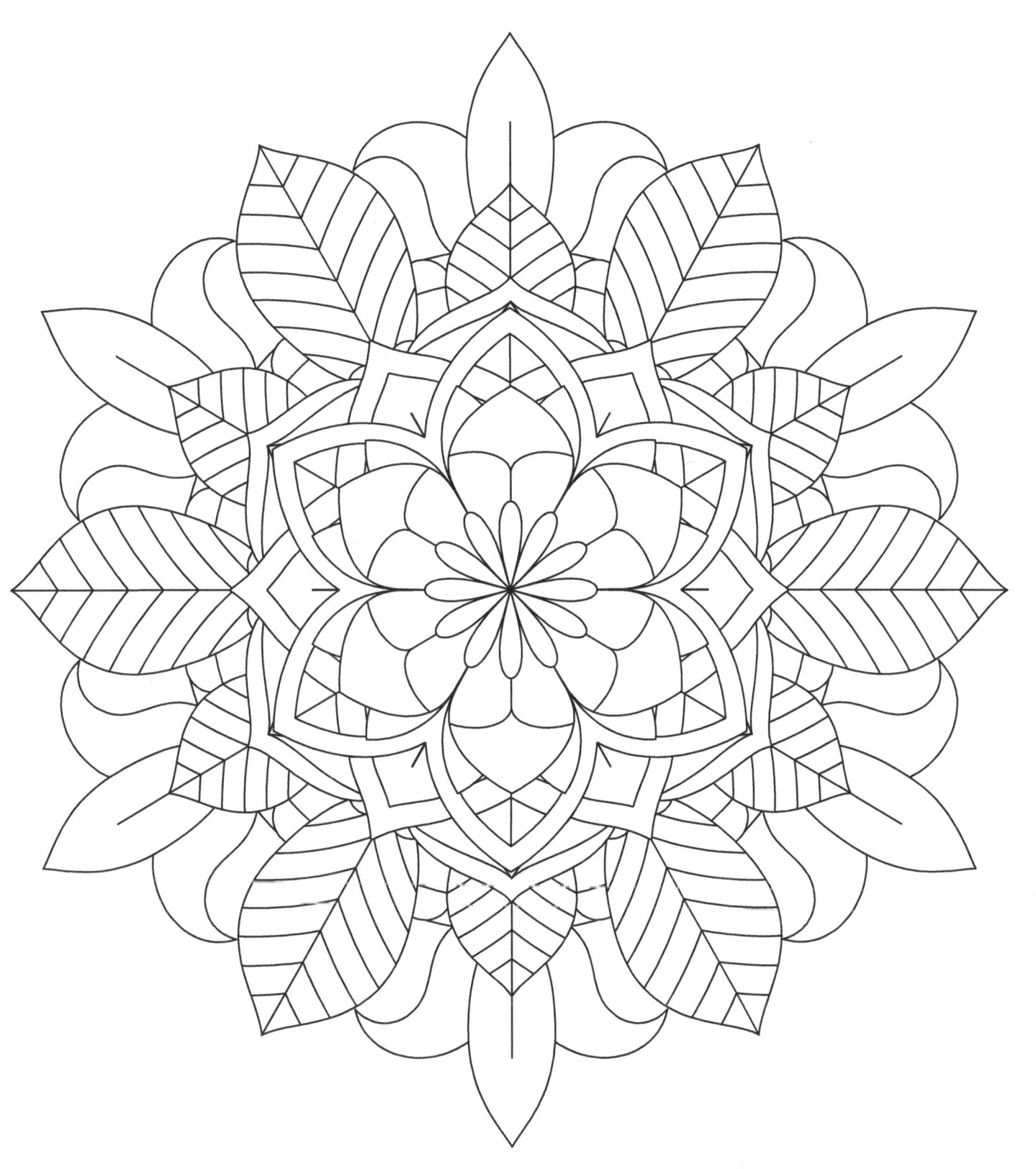

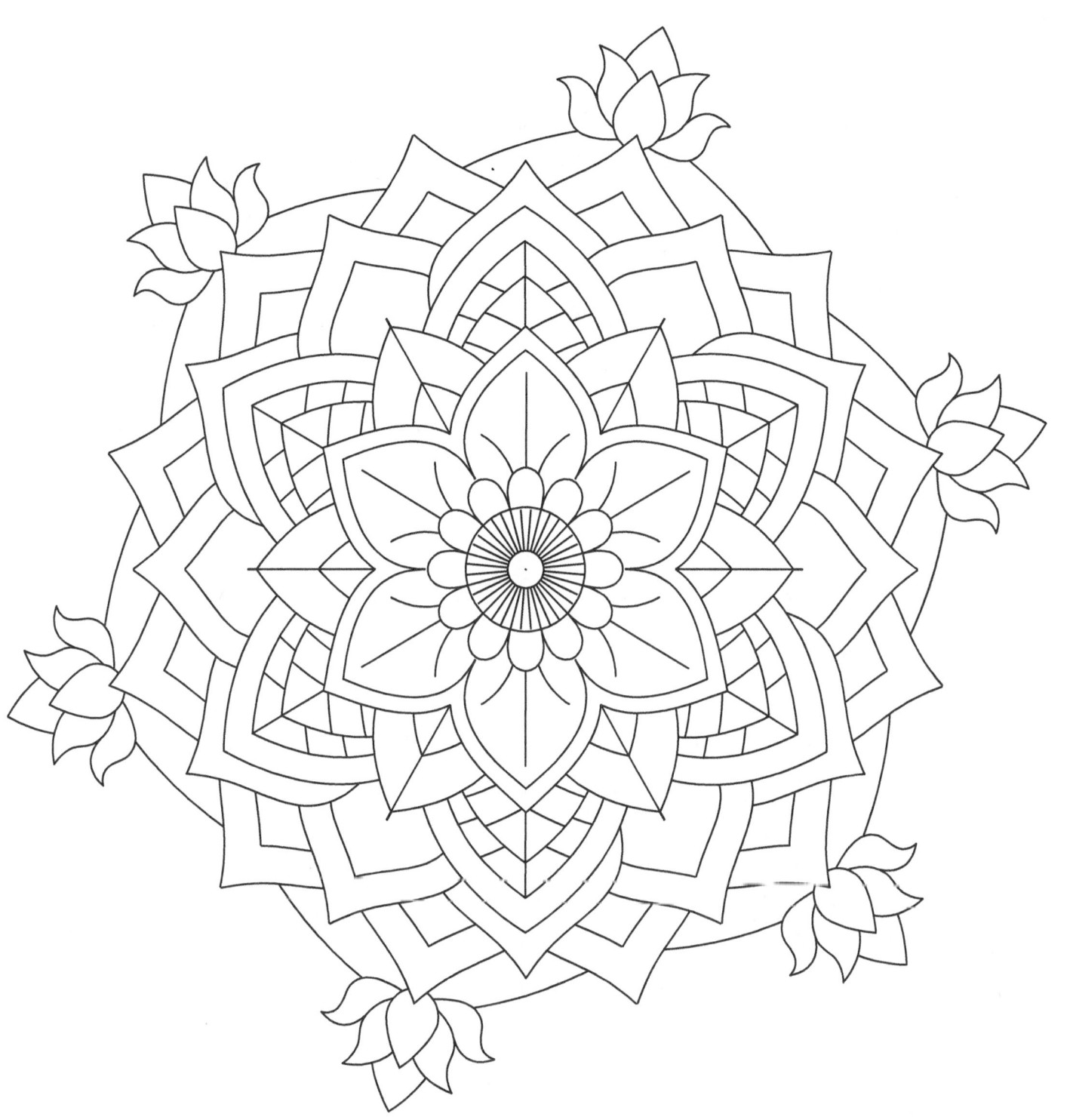

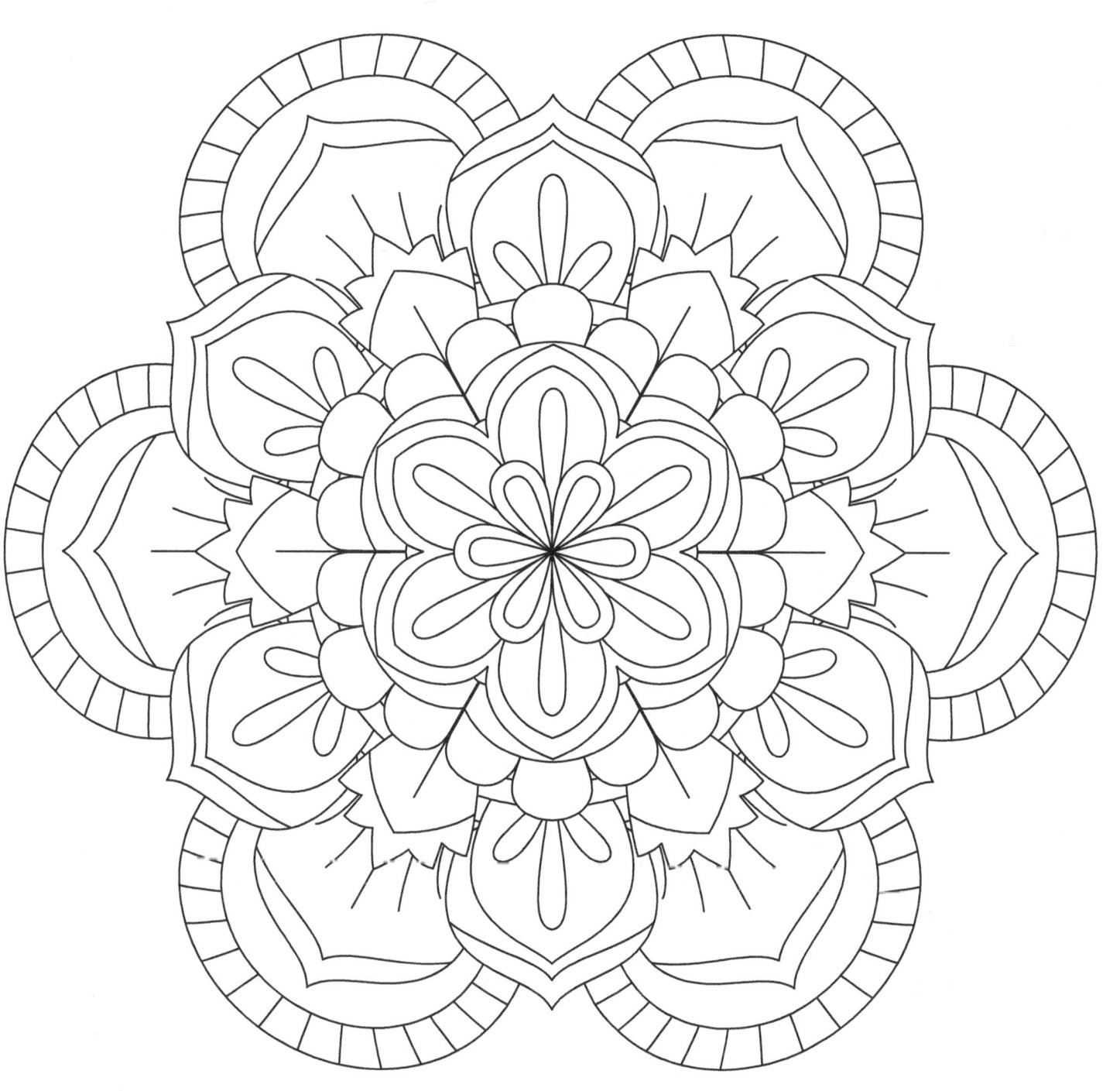

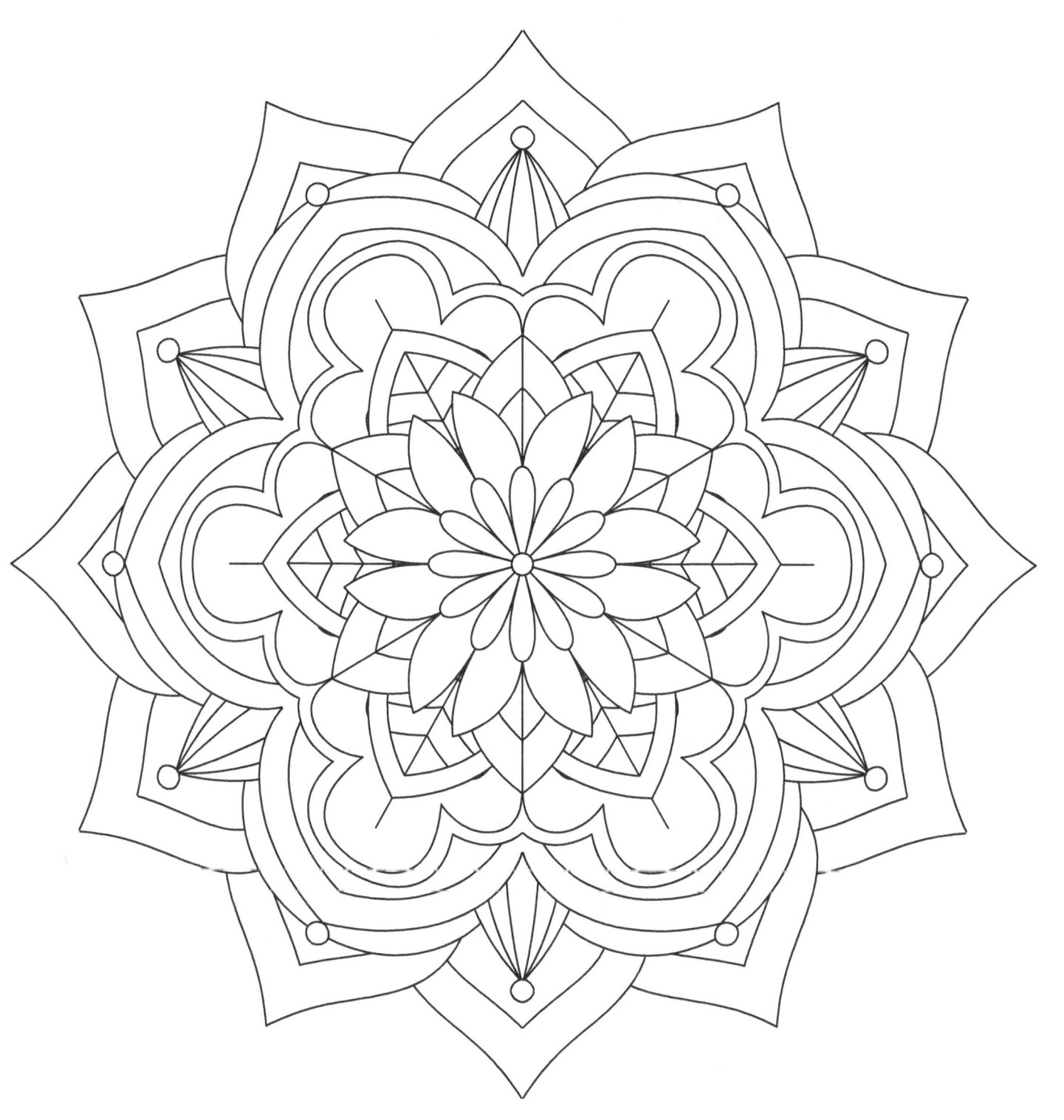

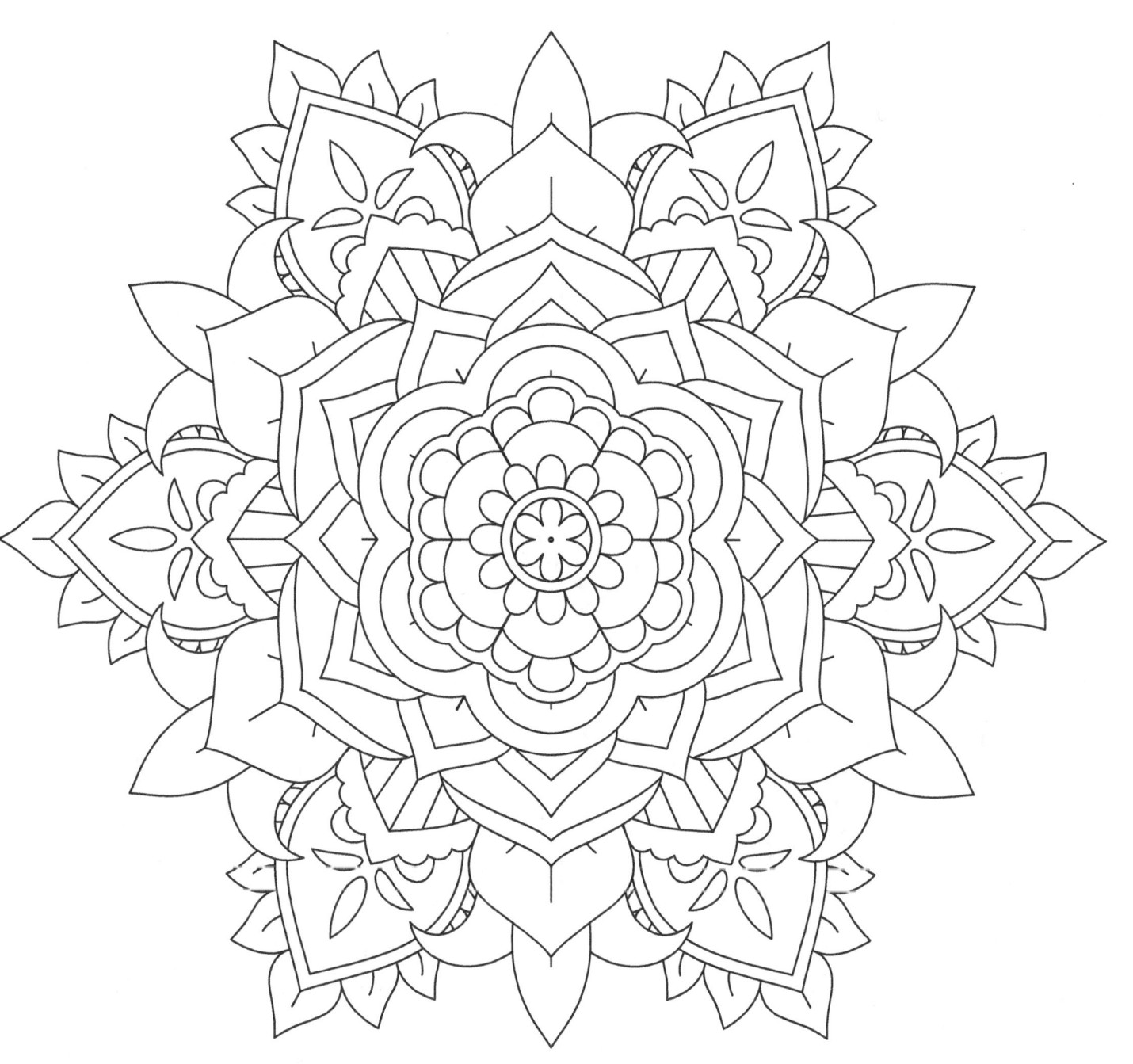

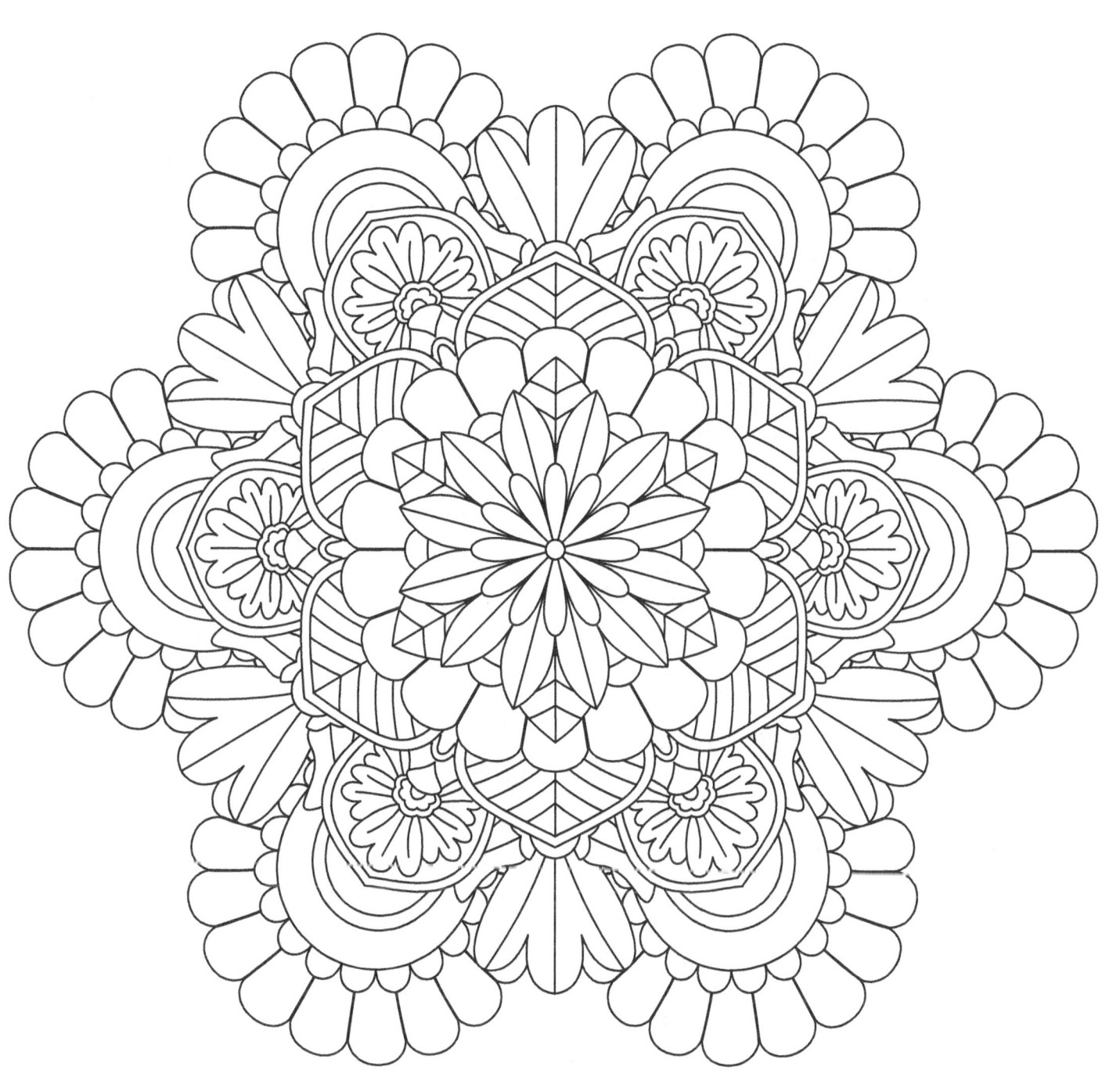

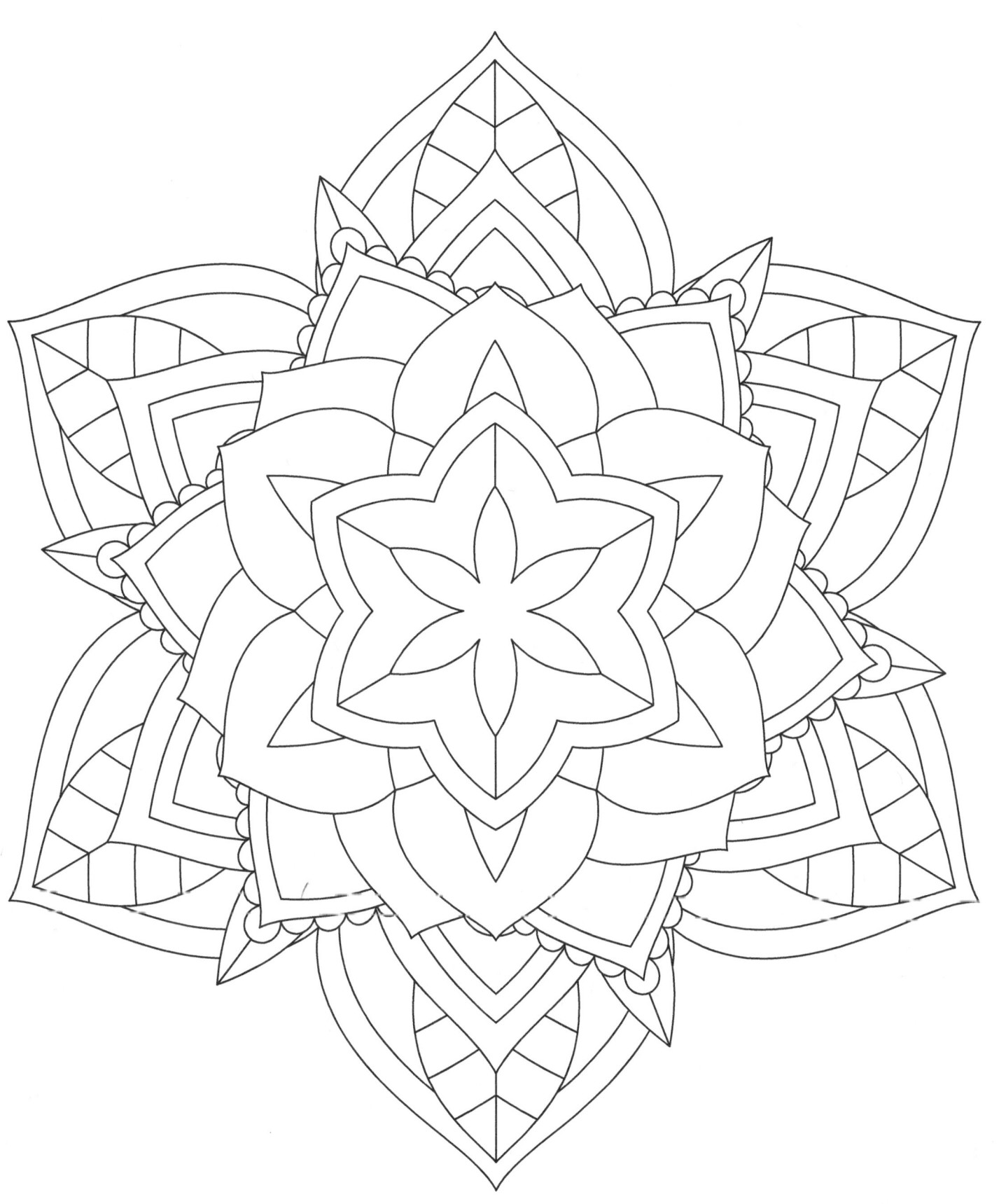

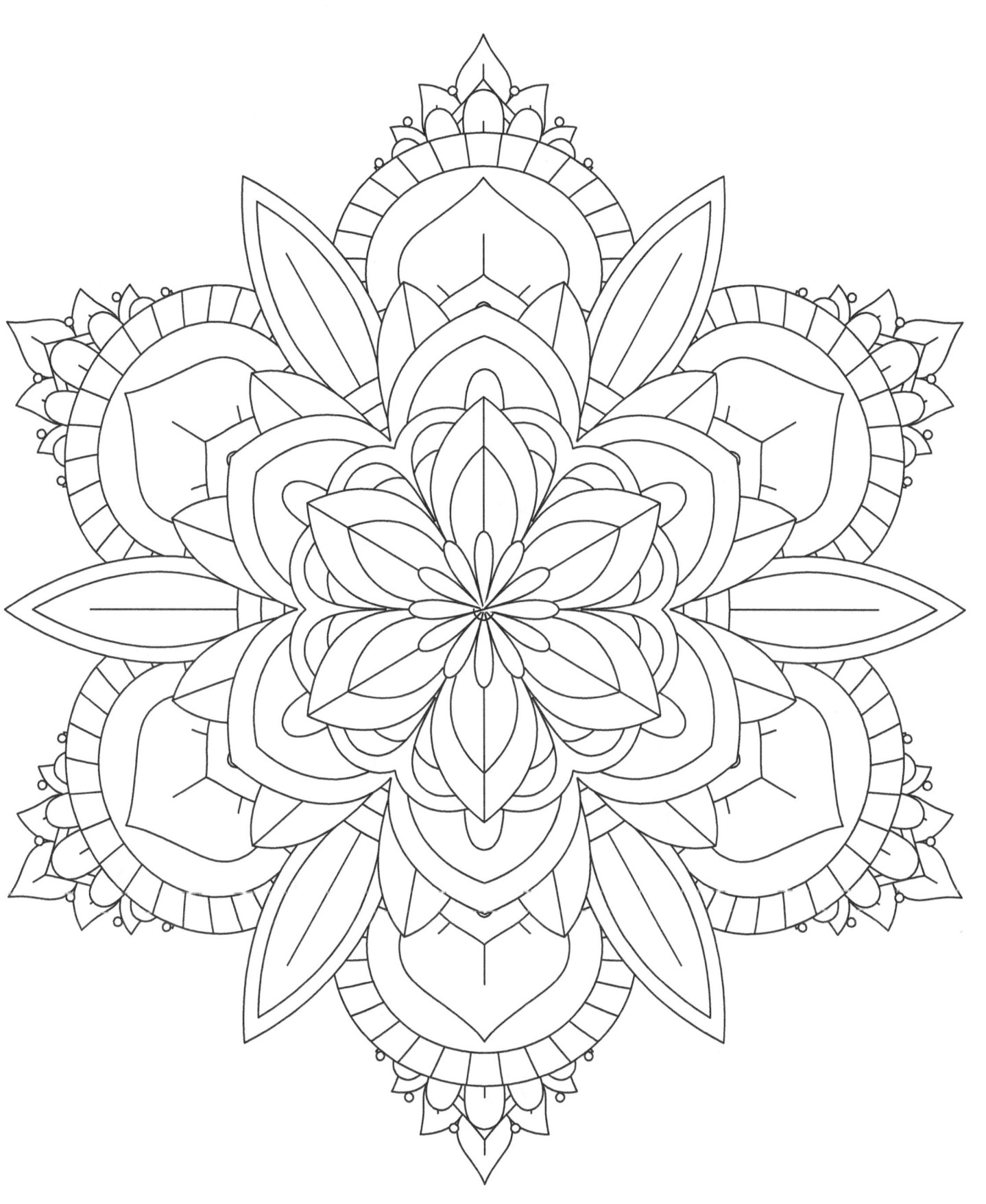

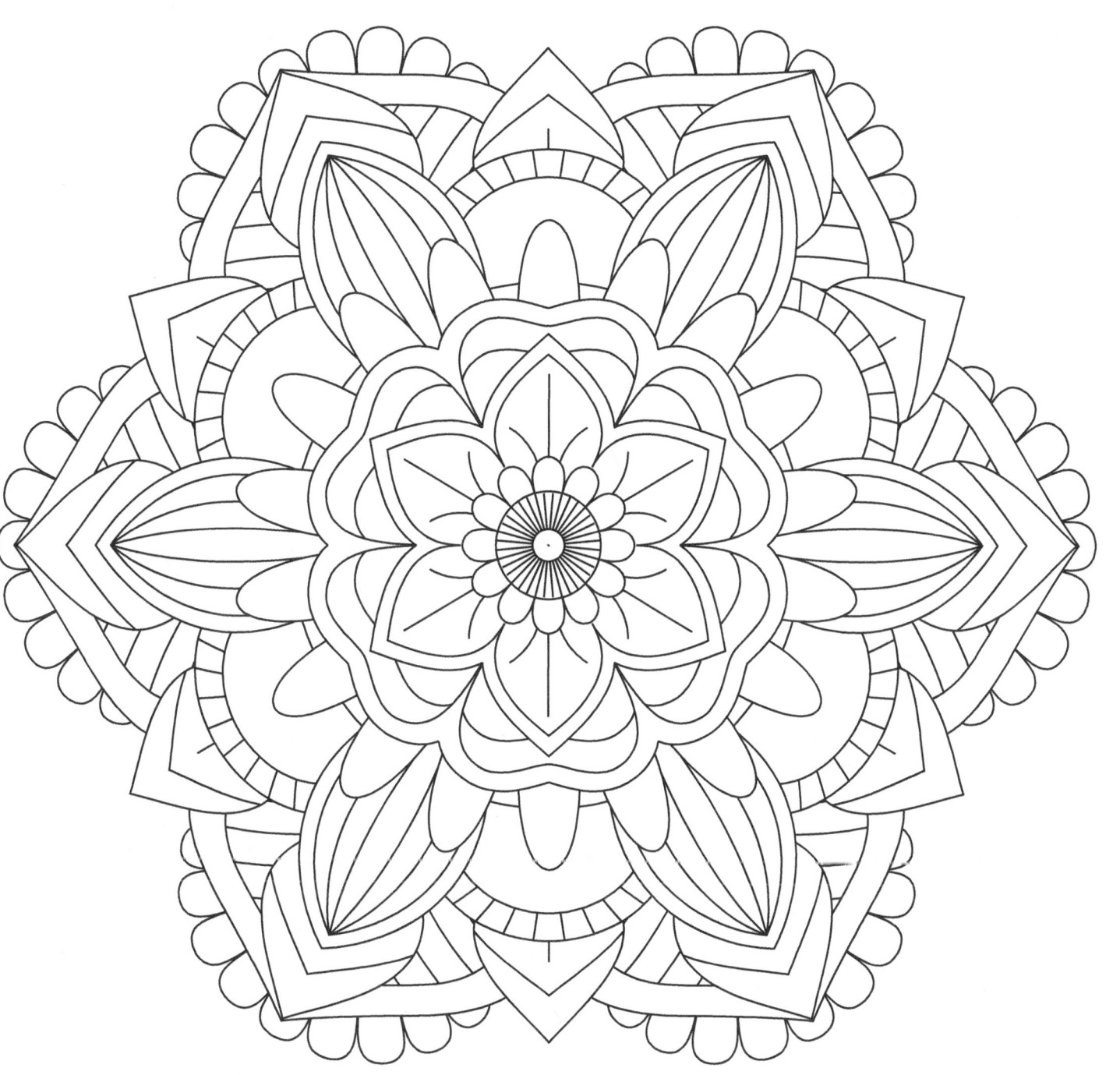

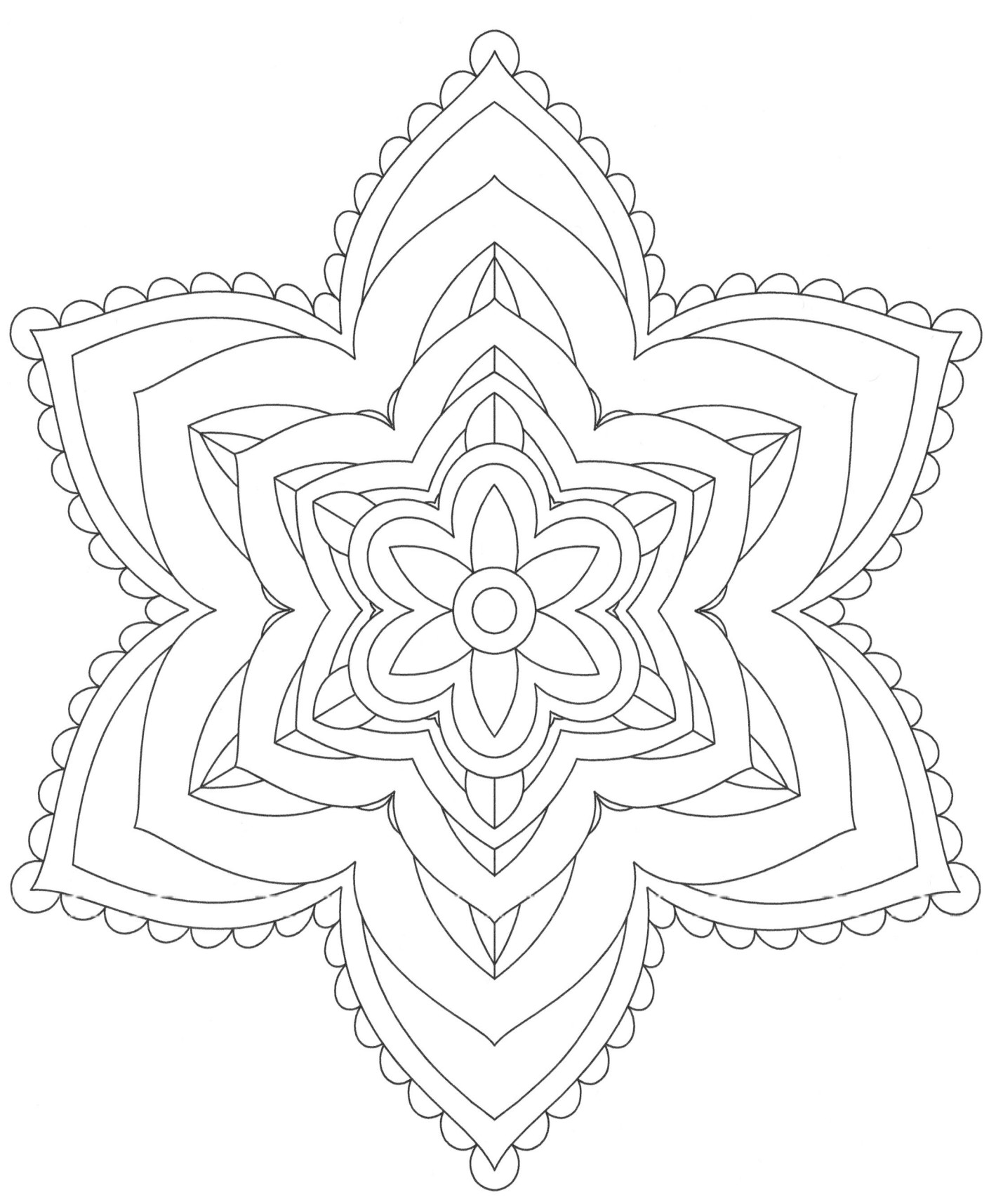

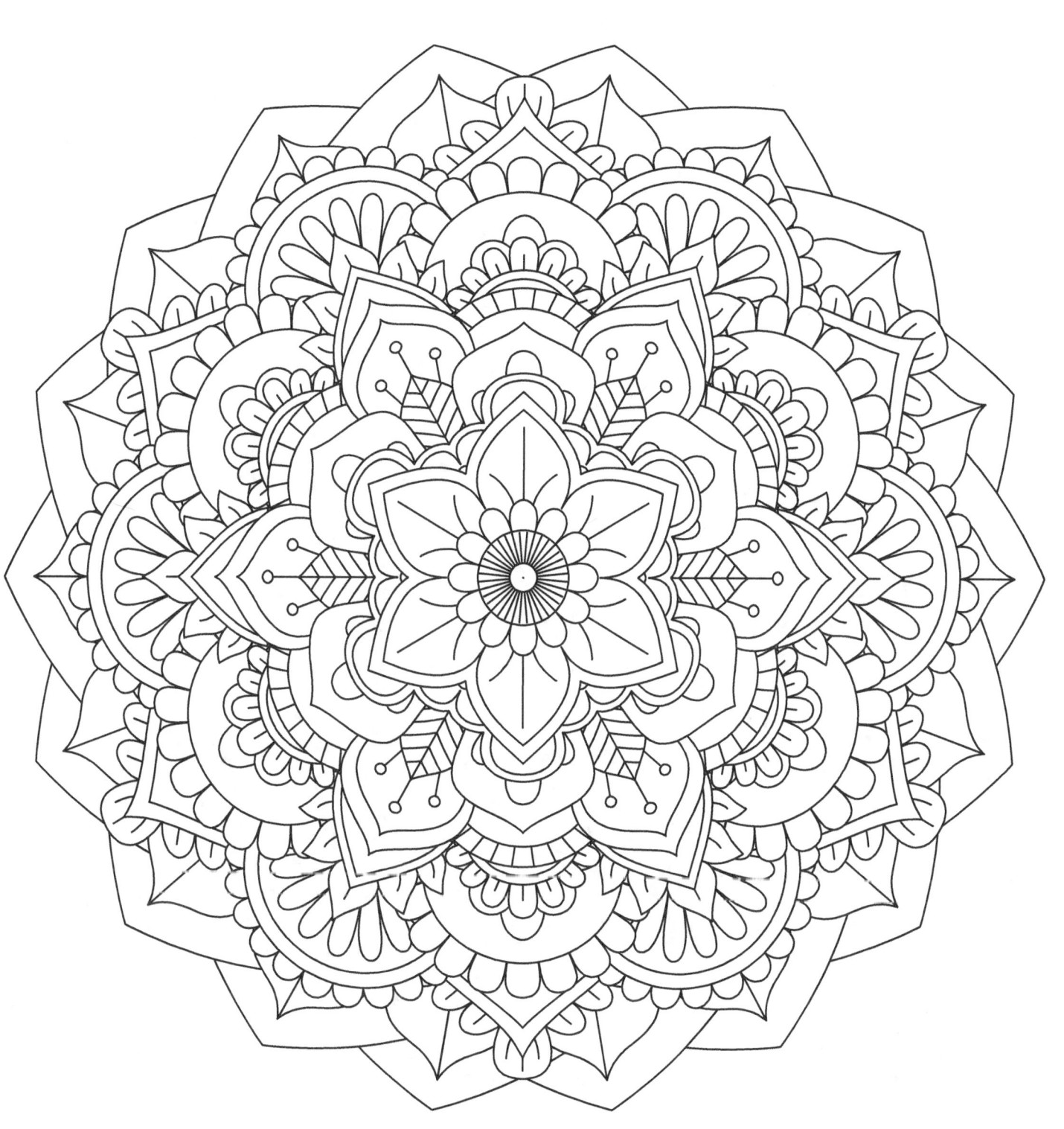

www.ingramcontent.com/pod-product-compliance
Lightning Source LLC
Chambersburg PA
CBHW081446220526
45466CB00008B/2523